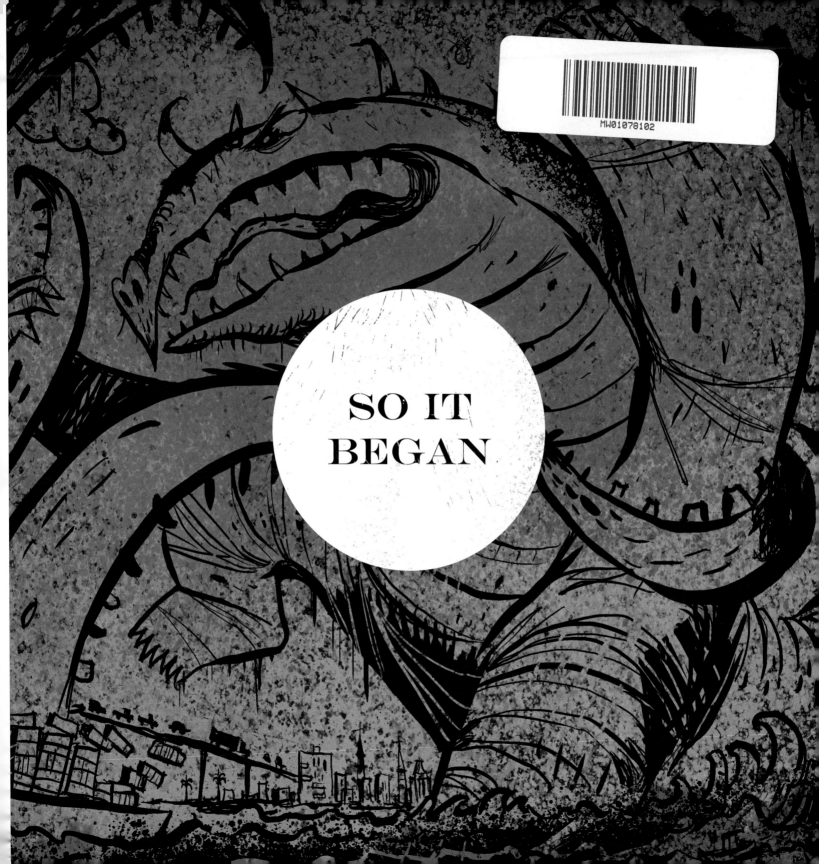

SO IT
BEGAN

"THE SCARIEST MONSTERS ARE THE ONES THAT LURK WITHIN OUR SOULS."

-Edgar Allan Poe

Created by

TIMOTHY BANKS

Library of Congress Control Number 2017902331
ISBN 978-1-5323-3369-9
Printed in the U.S.A. by Smartpress, Chanhassen, MN
First edition, November 2016
2 3 4 5 6 20 19 18 17

Produced and published by
BANKSCREATIVE® LLC
Mount Pleasant, South Carolina
bankscreative.com

TIMOTHY BANKS
timothybanks.com

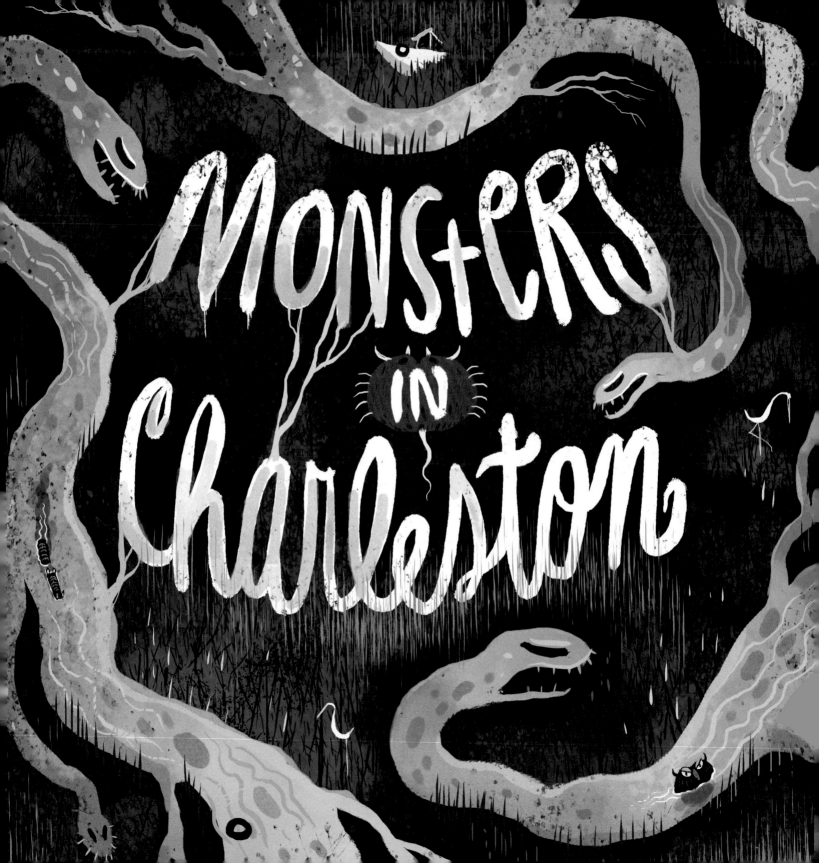

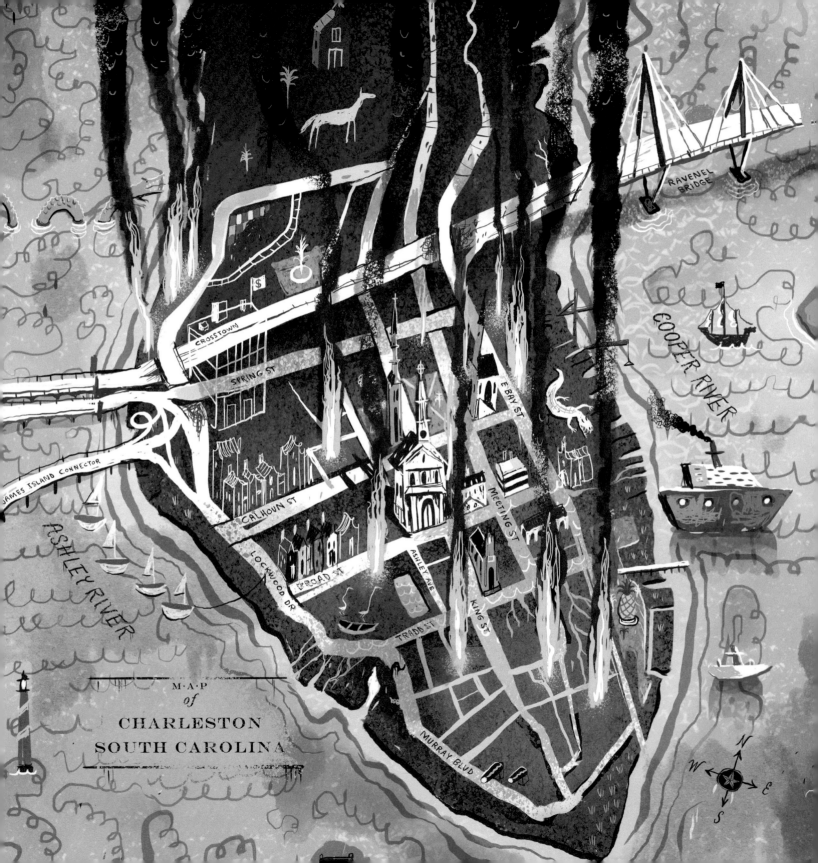

RAVENEL BRIDGE

COOPER RIVER

CROSSTOWN

SPRING ST

E BAY ST

JAMES ISLAND CONNECTOR

CALHOUN ST

MEETING ST

ASHLEY RIVER

LOCKWOOD DR

BROAD ST

ASHLEY AVE

KING ST

TRADD ST

M·A·P
of
CHARLESTON
SOUTH CAROLINA

MURRAY BLVD

N
W E
S

Contents

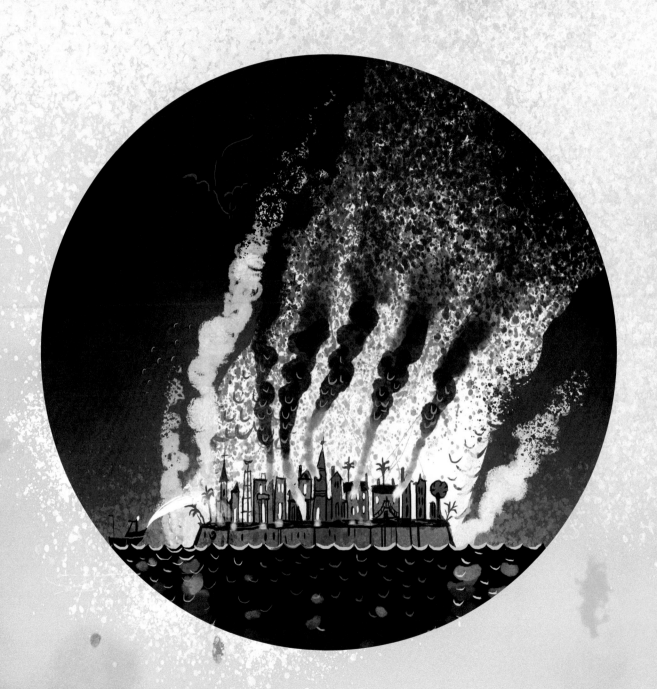

THE HOLY CITY WAS SUDDENLY UNDER ATTACK!

Bridges shook and the clouds clattered. Streets flooded (again) and fires broke out in distant burbs. They had arrived. Monsters from the ground, the air, the sea and Florida. They knew no boundaries, attacking tourists and locals alike. It was utter chaos and yet mildly enjoyable. The Monsters had made themselves at home and the Old Town once again practiced its most revered custom for them— bless their hearts hospitality.

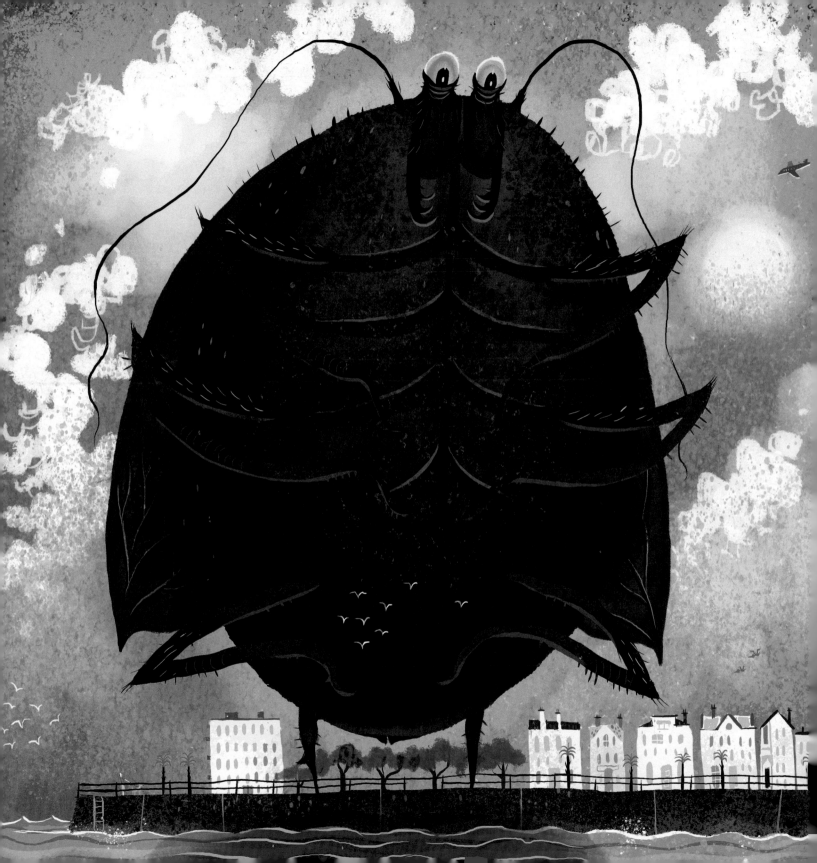

BATTERY
PALMETTO
BUG

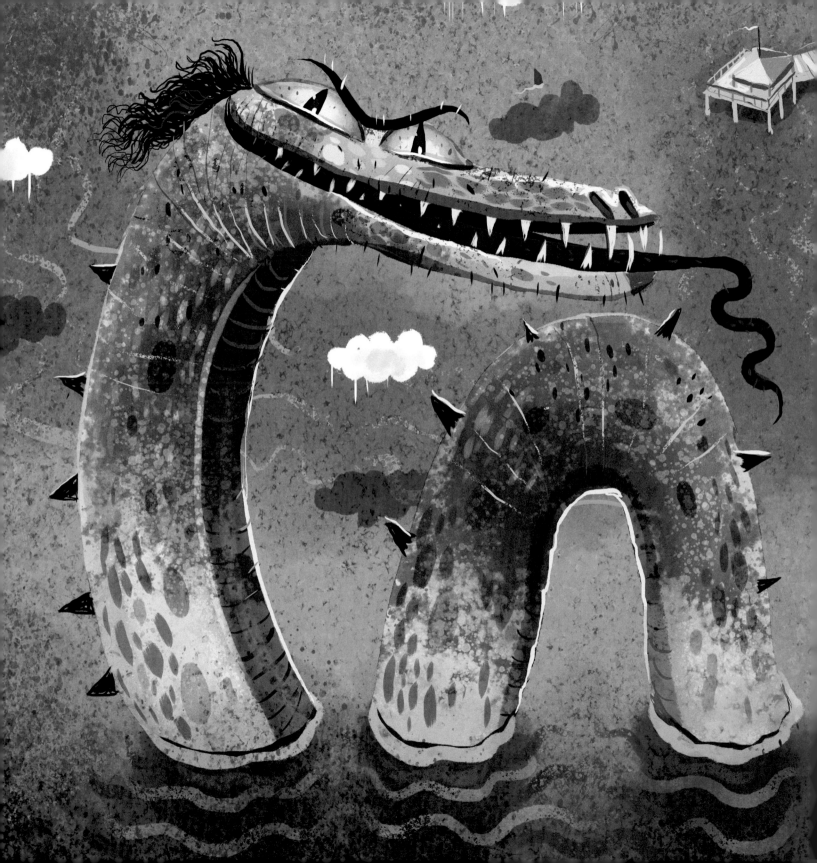

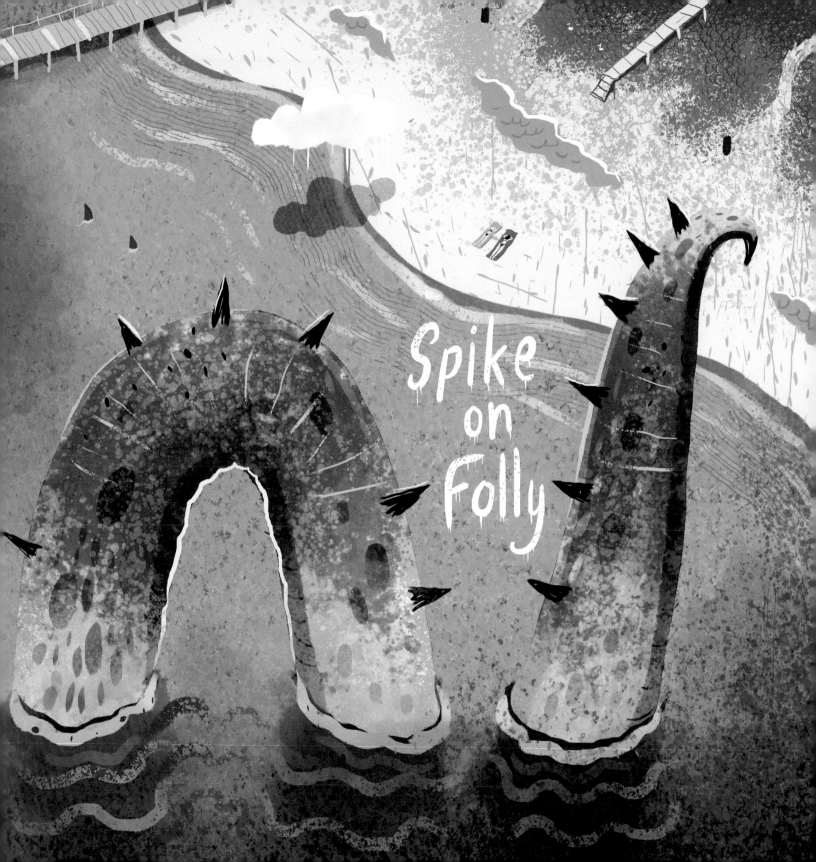

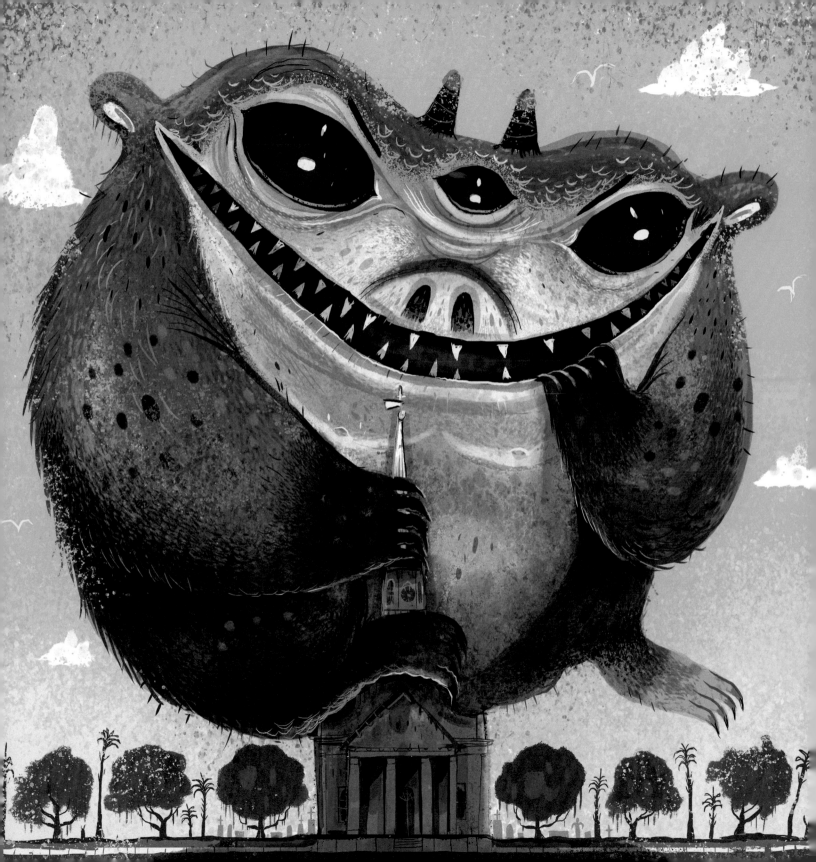

ST. MICHAEL'S LAST VISITOR

RAINBOW ROW
BAT INVASION

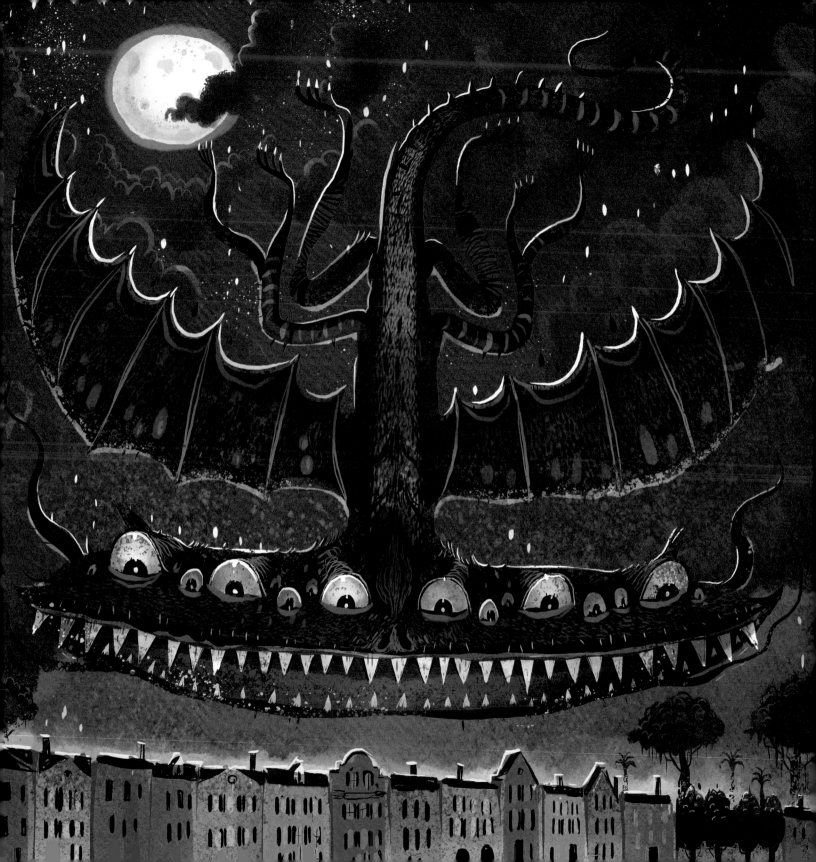

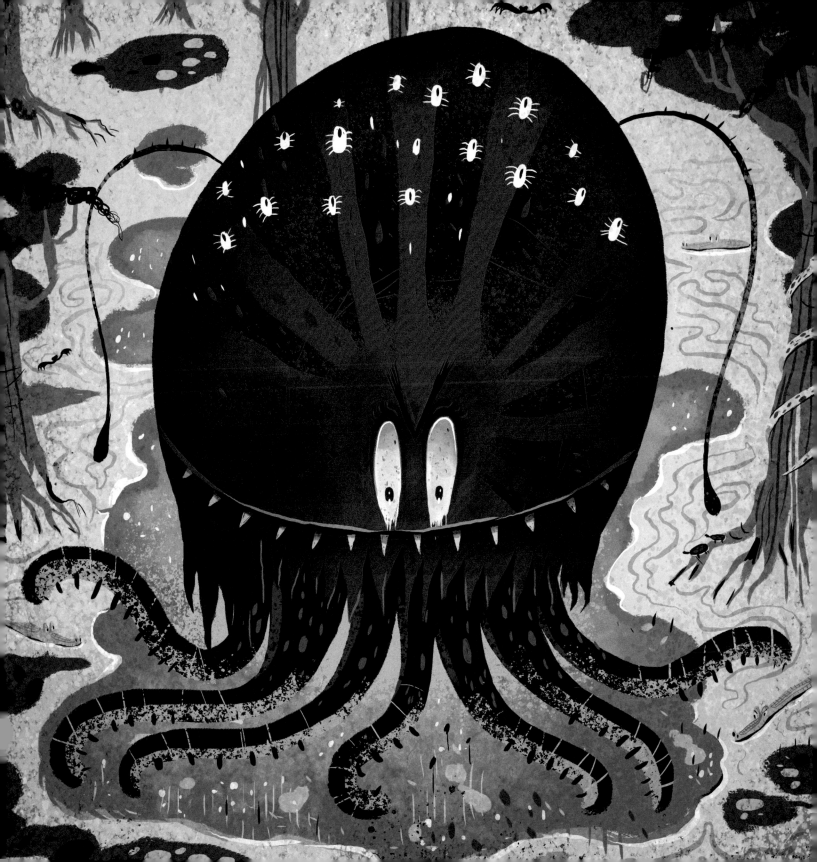

ELLYSSIUS
AT MAGNOLIA
GARDENS &
SWAMP

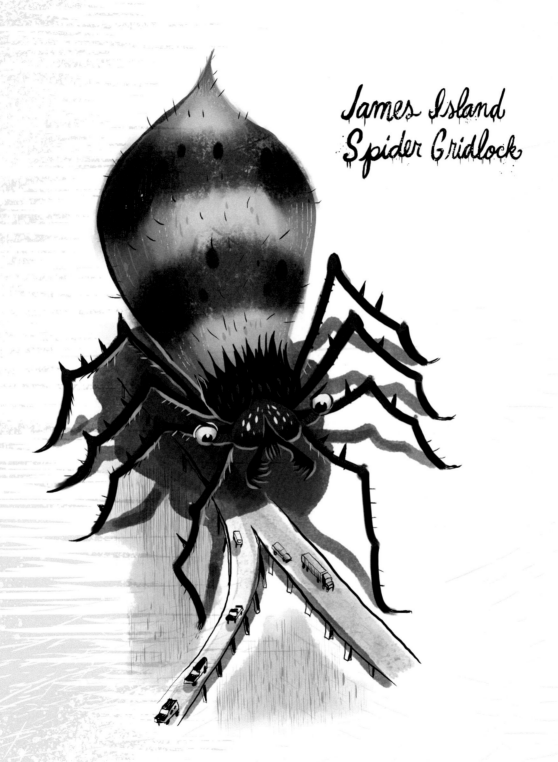

James Island
Spider Gridlock

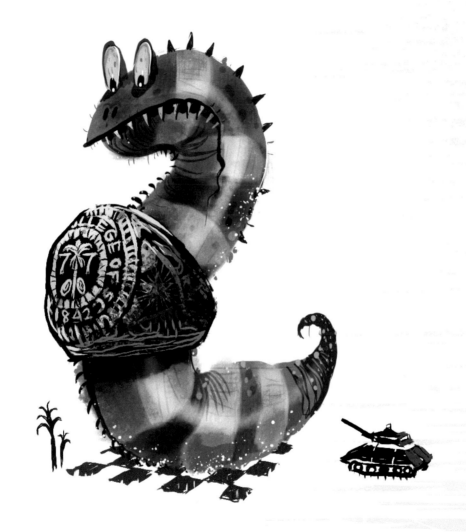

Citadel Worm Knob

ANGEL OAK
UNDER ATTACK

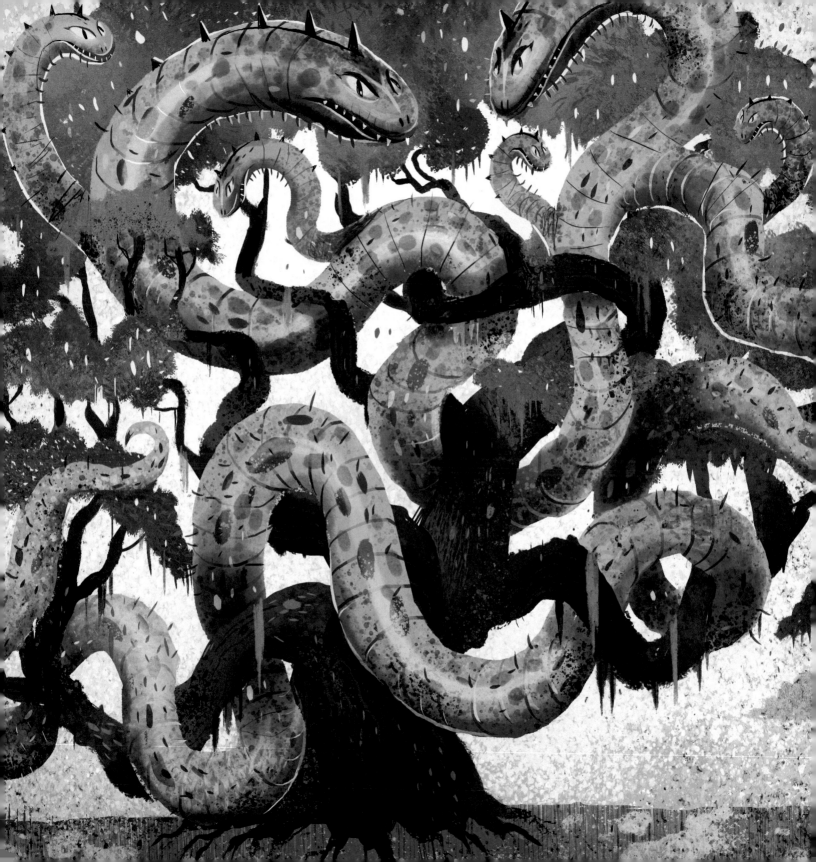

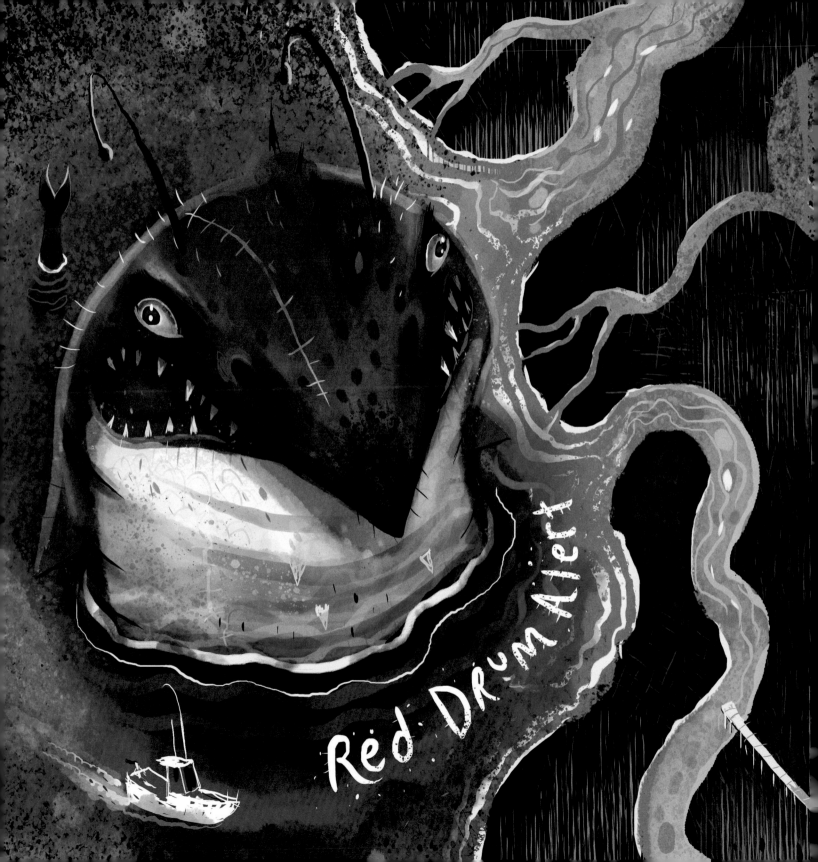

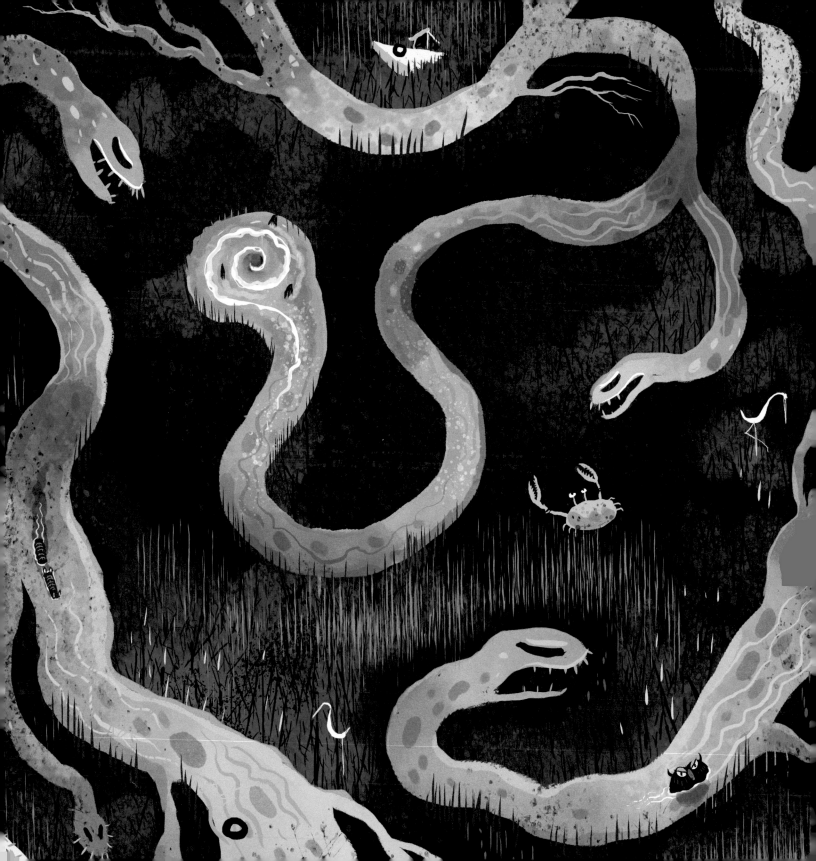

BOBO ENJOYS CHARLESTOWNE LANDING

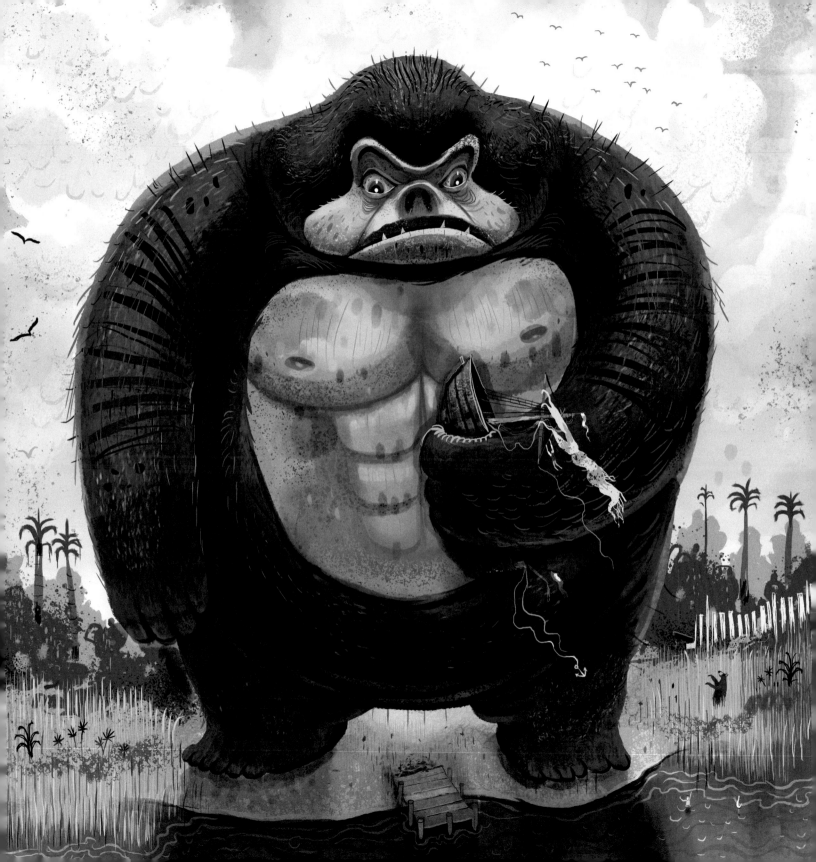

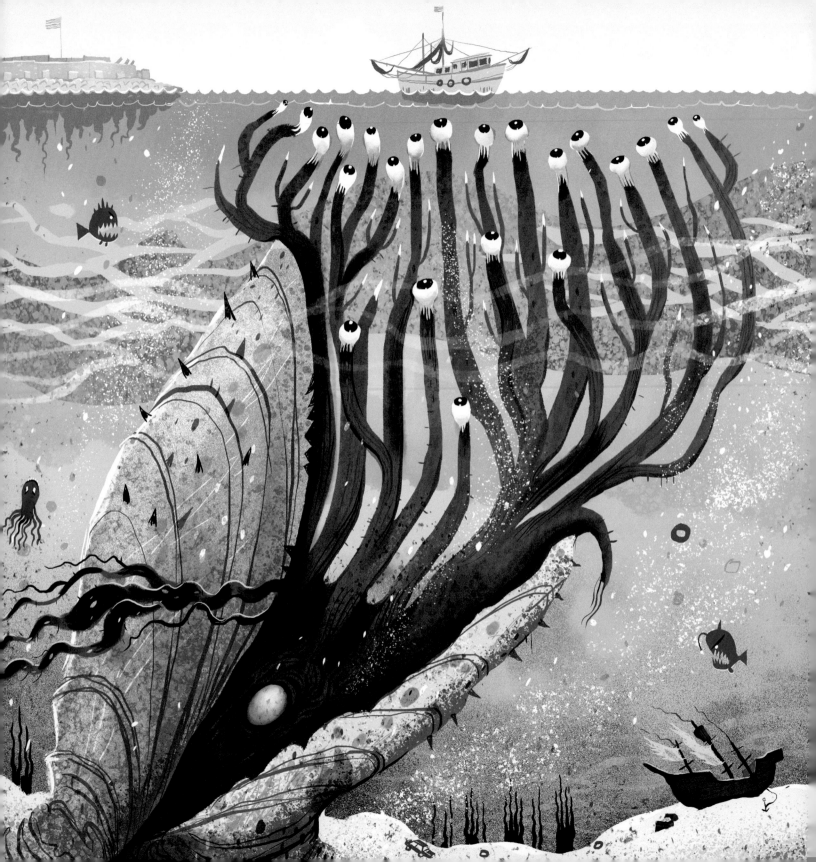

THE LAST
SHRIMP BOAT

SNAIL RECKONING
ON SULLIVAN'S

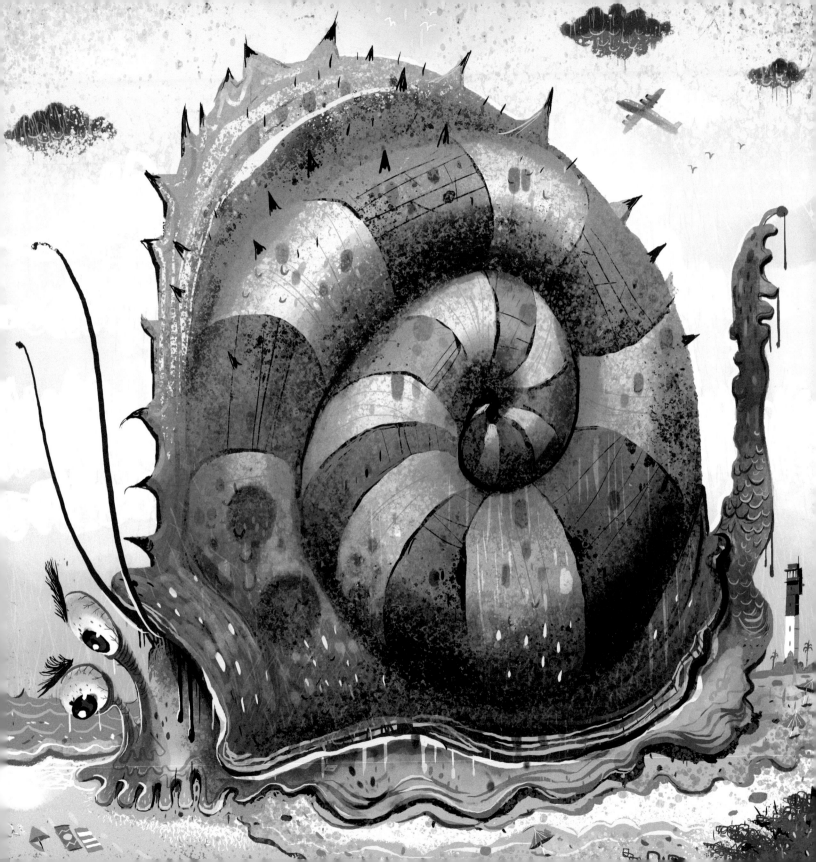

Monsterquito Ravenel Bridge Stress Test

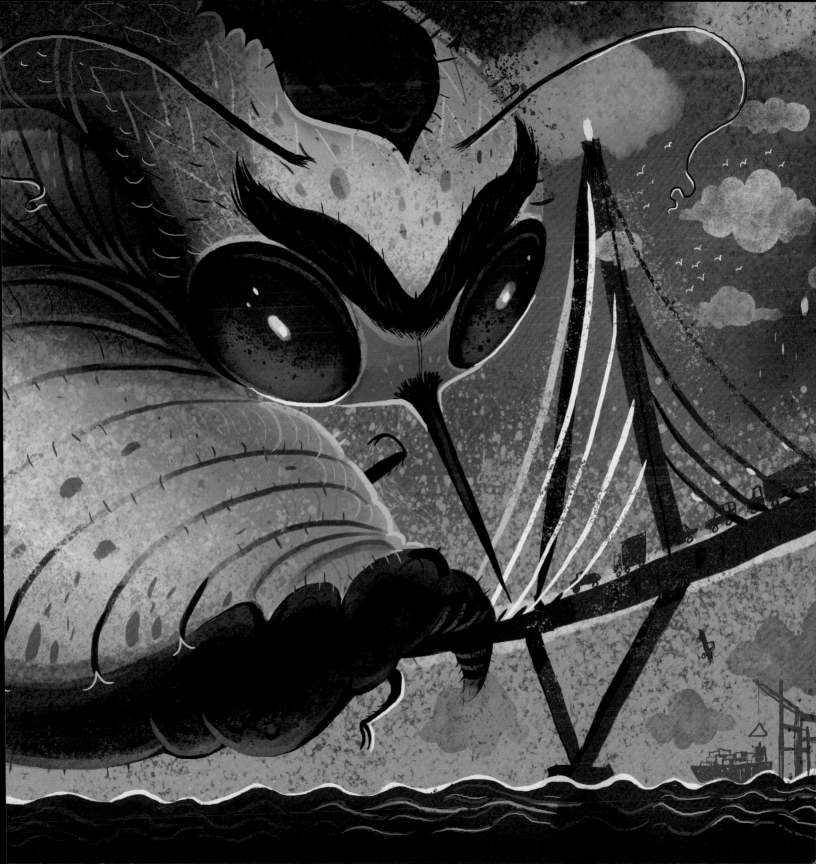

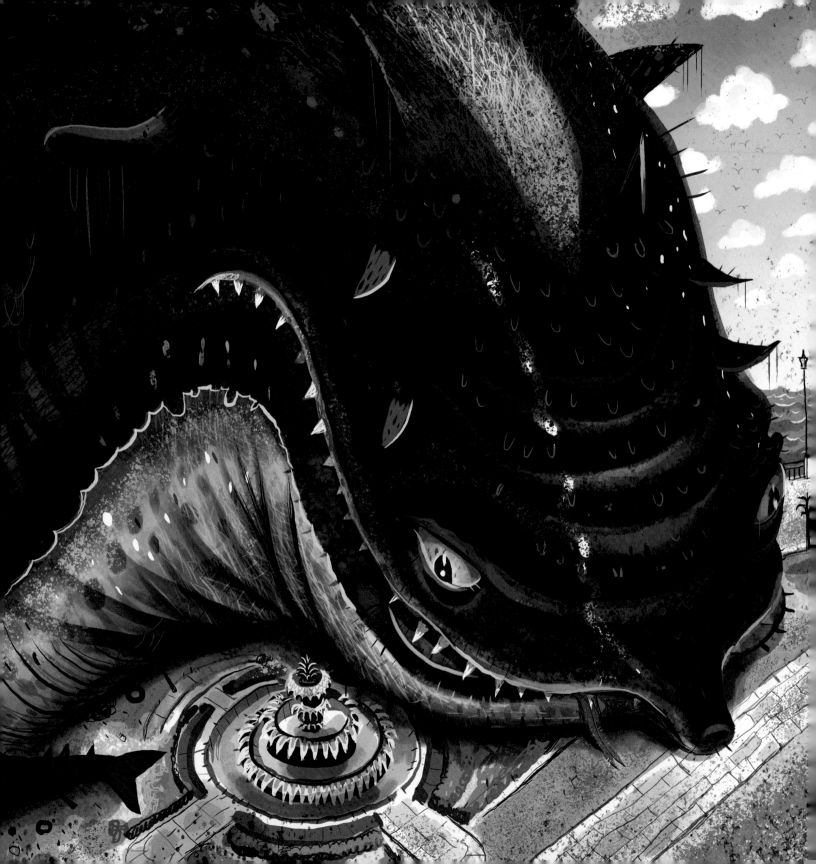

MUTANT DOLPHIN SIGHTING AT WATERFRONT PARK

DRAGON ON MARKET

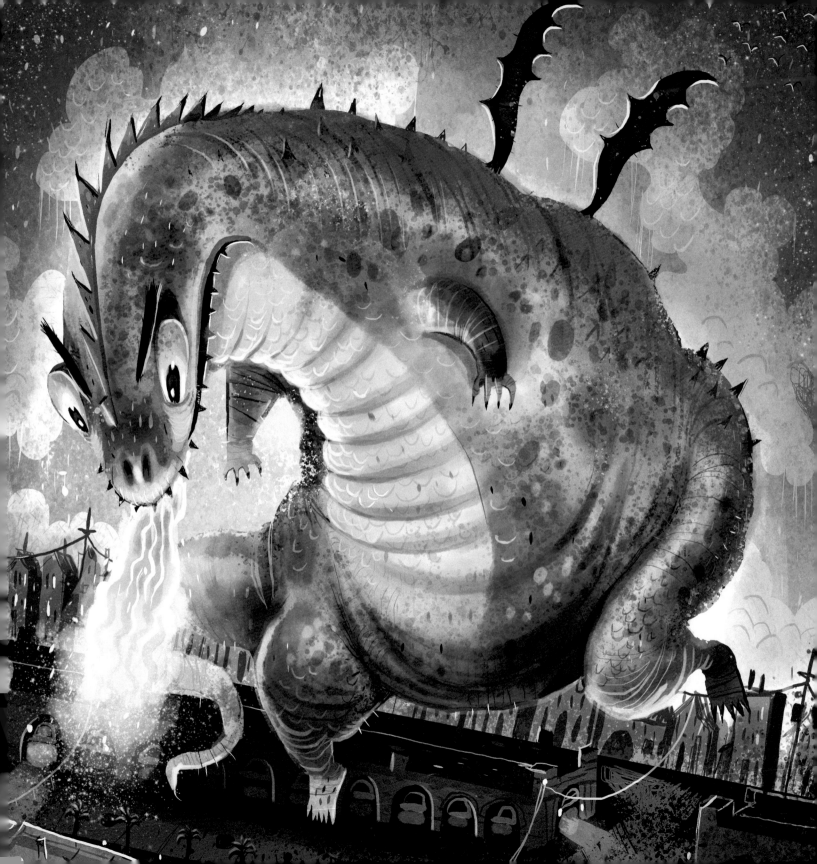

-Peter Venkman

"THIS CITY IS HEADED FOR A DISASTER OF BIBLICAL PROPORTIONS."

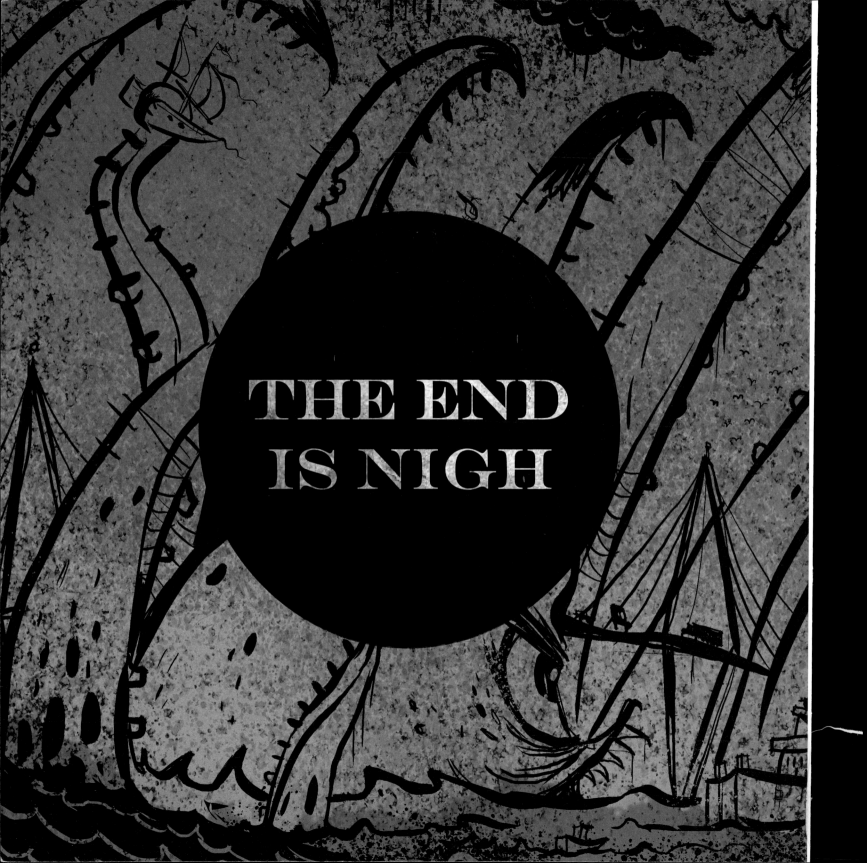